Southeast Texas New Millennium Cowboy 1999-2010

Shane Elizabeth Proctor

Copyright © 2012 Shane Elizabeth Proctor

All rights reserved.

ISBN: 1493763059
ISBN-13: 9781493763054

To all my friends and family who have enjoyed these images as much as I have.

Southeast Texas New Millennium Cowboy Pictorial is a compilation of some of my favorite actions shots, as well as some shots that just made the cut. I dedicate this pictorial to the many friends and family who inspired me to photograph the African American Cowboy in action. I have an extensive collection of images of African American Cowboys who show their love and skill for the sport. I deemed it necessary to share the images that I so love and cherish with the world because there are not many images of the African American Cowboy in action. The African American Cowboy is alive and well. This is the first edition of Southeast Texas New Millennium Cowboy. I hope that the images will be enjoyed and appreciated by others at the same level that I appreciate and enjoy the images.

Shane Elizabeth Proctor

Calf Roping/ Tie-Down

Tie-down roping, formerly known as calf roping is the classic old west ranch chore. It is now one of the most competitive of rodeo events. Tie-down ropers compete against each other and the clock for the **prize** money.

Like the **steer wrestlers** and **team ropers**, tie-down ropers start in the **box** ready to compete. The calf is released and the cowboy must rope it as quickly as possible. As soon as a catch is made the cowboy dismounts, sprints to the calf and tosses it on its side, which is called flanking. With a small rope known as a pigging string, usually held in the cowboy's teeth, any three of the calf's legs are tied securely. Time stops when the cowboy throws up his hands.

After the tie, the roper remounts his horse, puts slack in his rope and waits 6 seconds for the calf to struggle free. If it does, the cowboy receives a no time and is effectively disqualified from the round. If the calf remains tied the cowboy receives his time. As in the other timed events, if the roper **breaks the barrier** he receives a 10 second penalty added to his time.

Tie-down roping requires timing, speed, agility, and strength. It also requires a highly trained horse. Horses in the tie-down roping **play** a major role in the success of the competitor. Horses are taught to know when to start walking backward thereby keeping the rope taught and allowing the cowboy to do their work on the other end. It is truly amazing to watch as cowboy and horse compete together in this modern sporting event.

This is one of my first action shots taken in 1999 at the Diamond L Ranch in Houston, Texas.

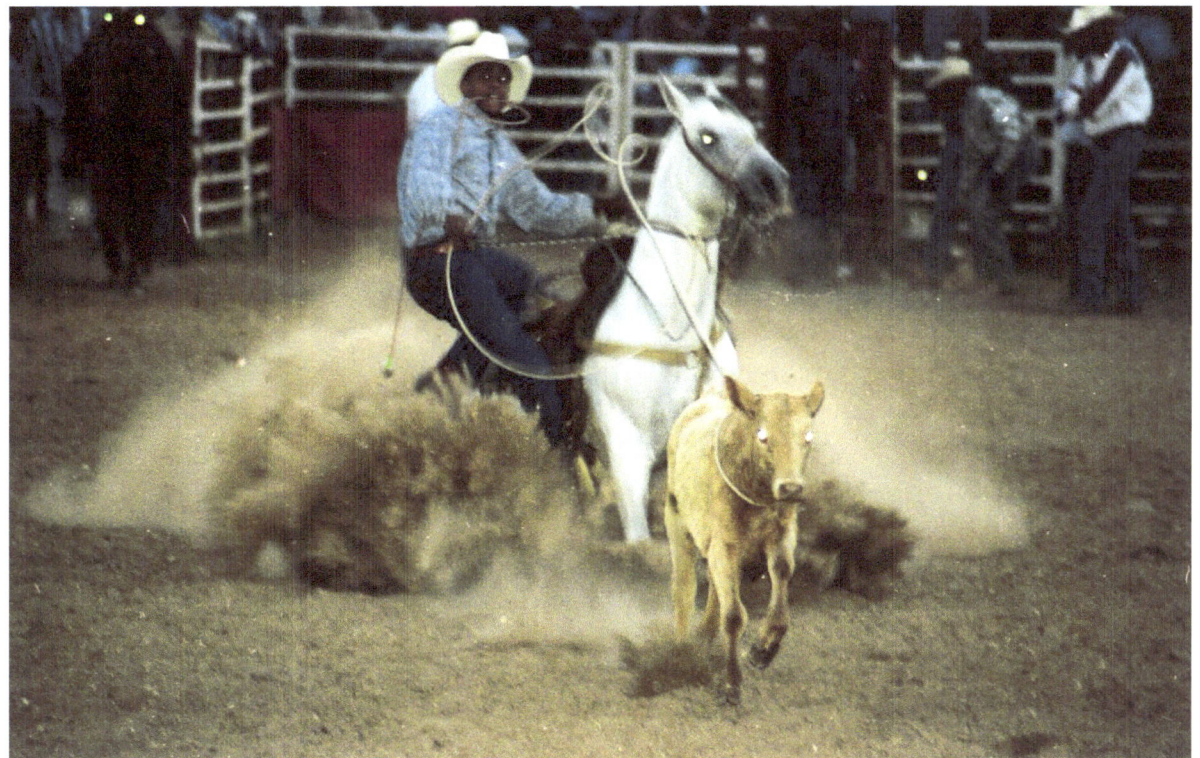

Cowboy

Stephen Davis

Calf Roper

This is a shot of my father who introduced me to the business of rodeo photography. This photo was taken at Carlyle Kings Roping Arena.

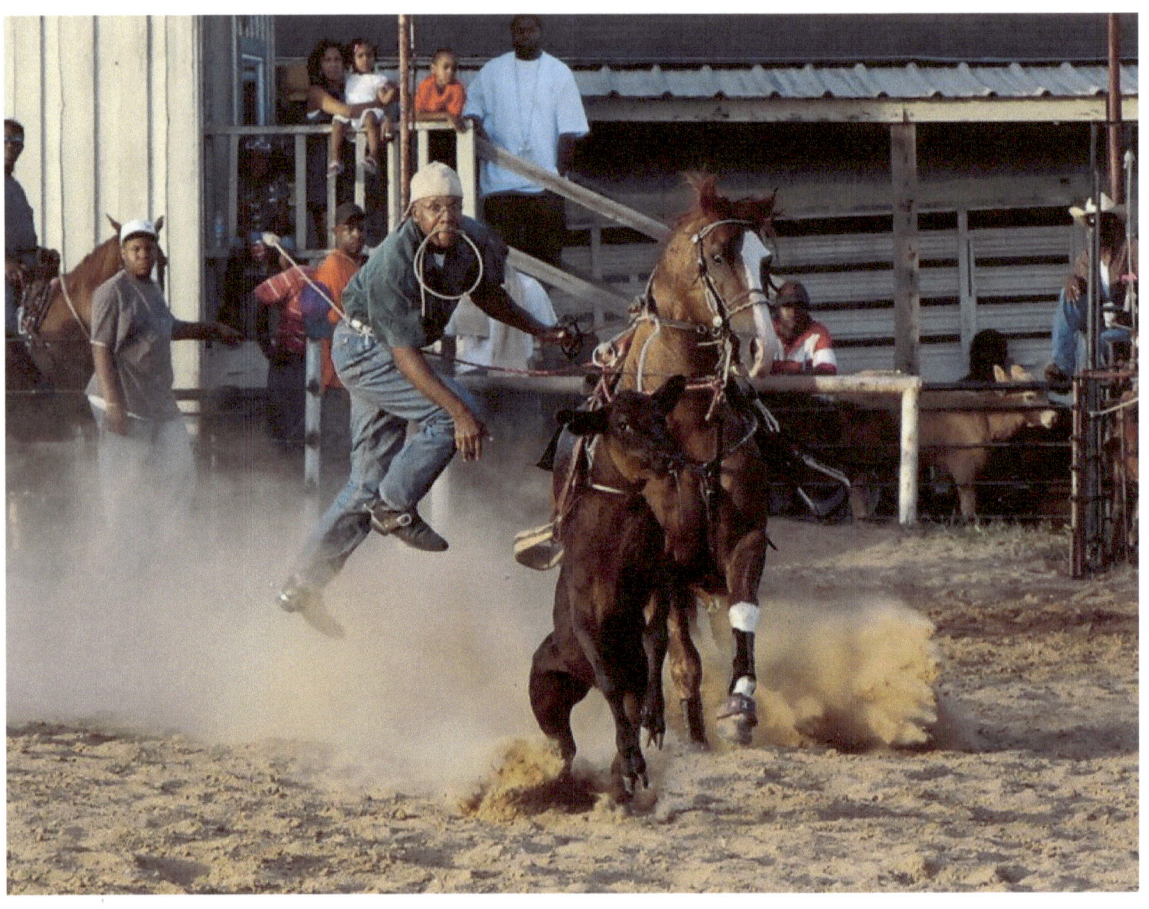

Cowboy
Sidney L. Johnson
Calf Roper

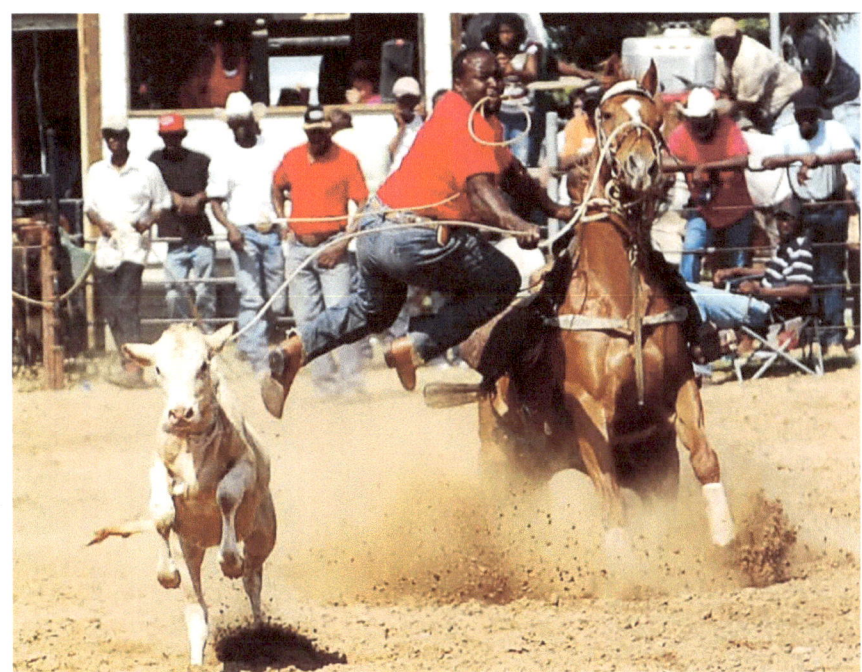

Cowboy, Unknown
Calf Roper
Carlyle King's Roping Arena

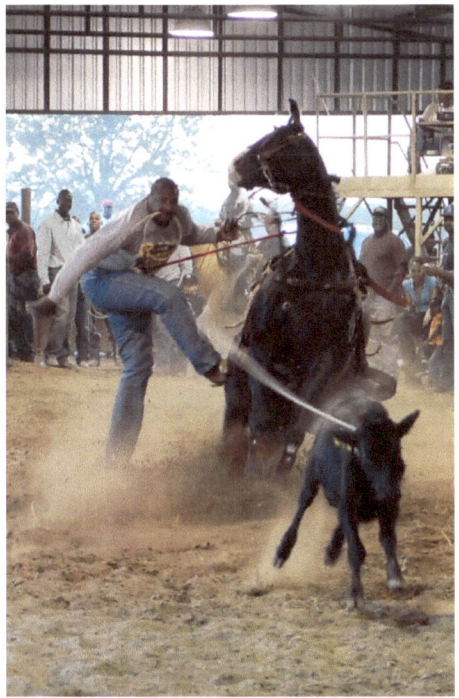

Cowboy, Willie Murray
Calf Roper
Dana William's Roping Arena

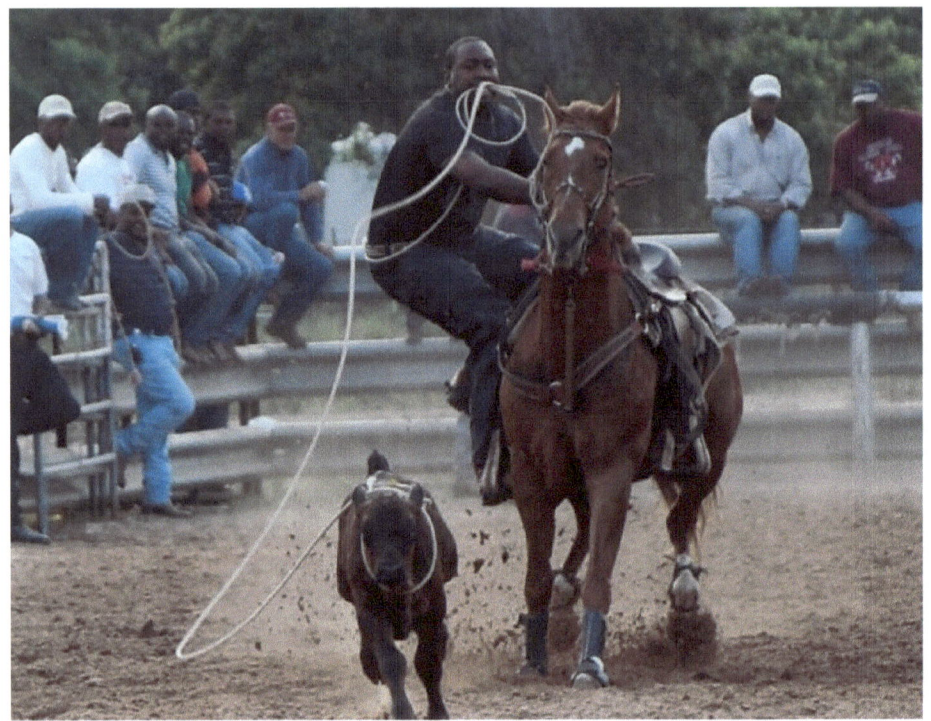

Cowboy-Unknown
Calf Roper

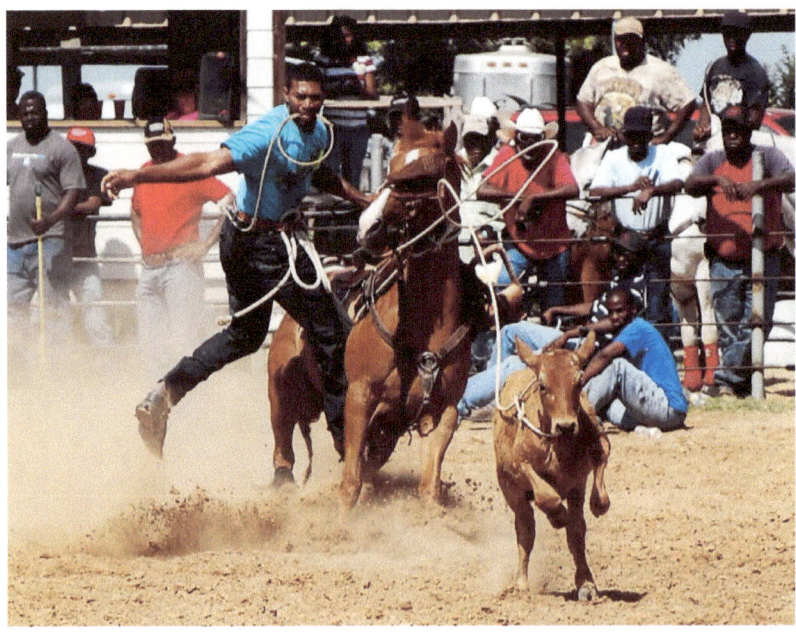

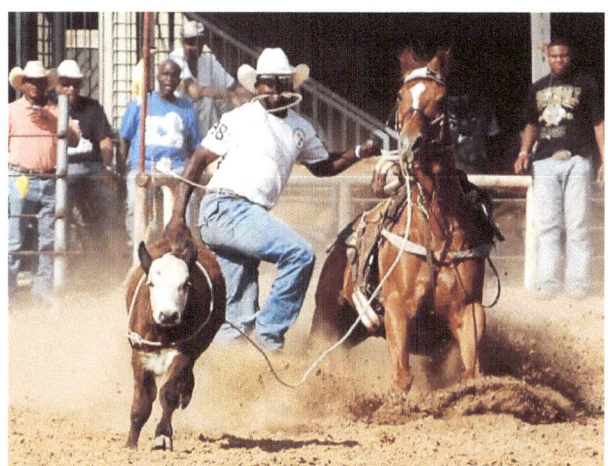

Cowboy Unknown
Calf Roper

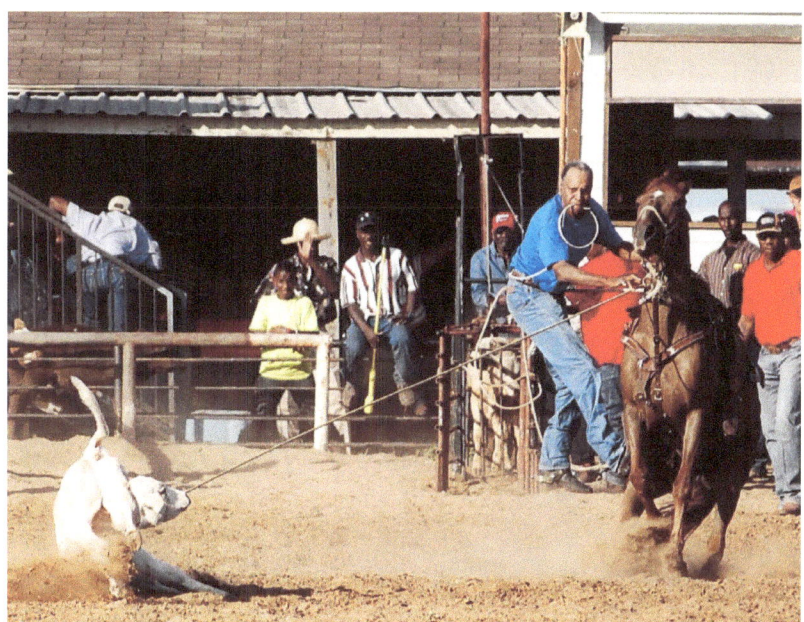

Cowboy Johnnie Gold
Calf Roper

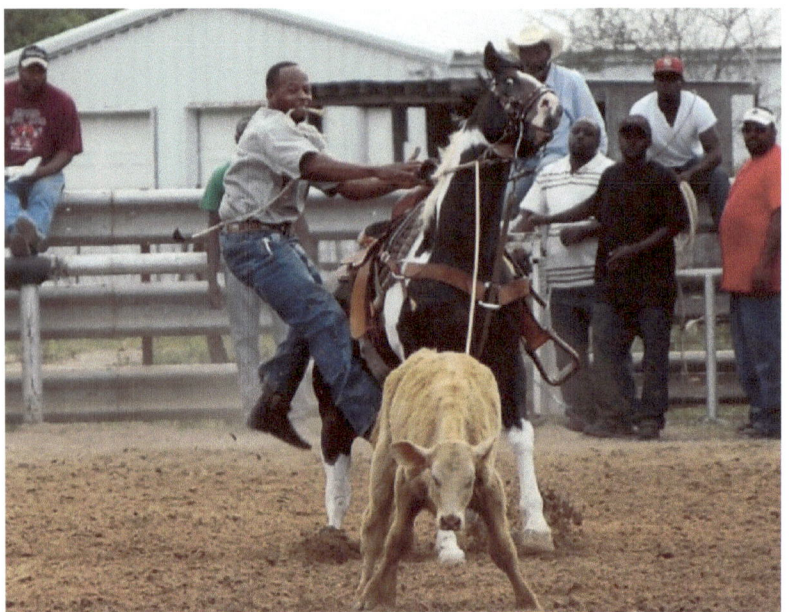

Cowboy-Unknown
Calf Roper

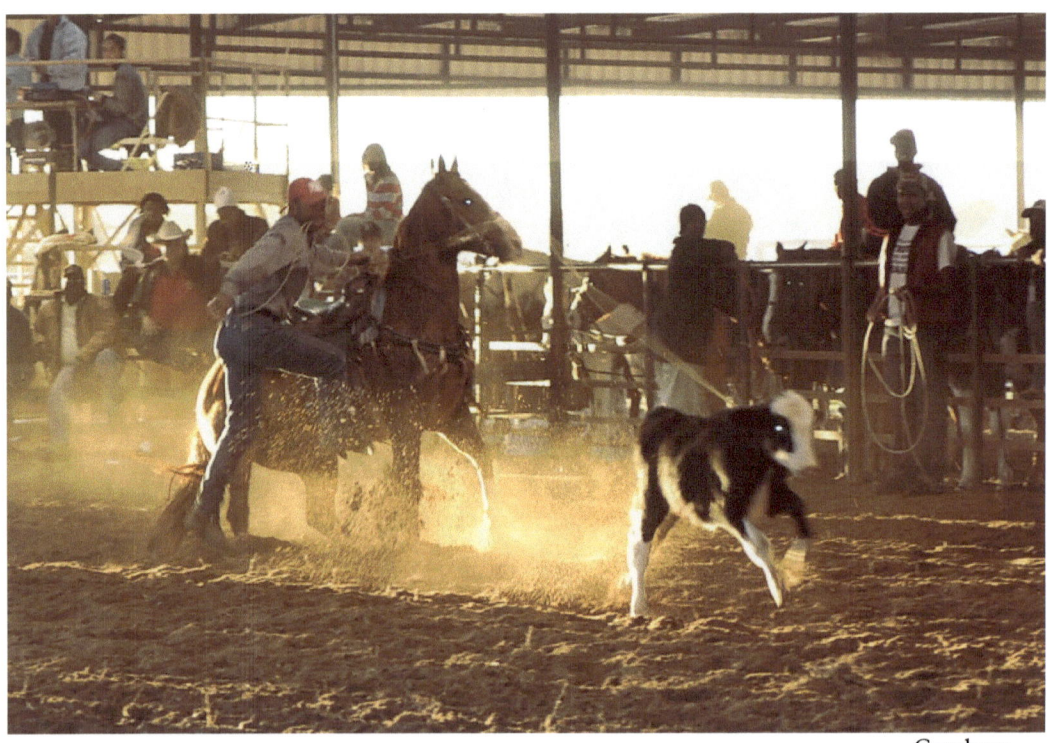

Cowboy
Dana Williams
Dana Williams Arena
Hempstead, Texas

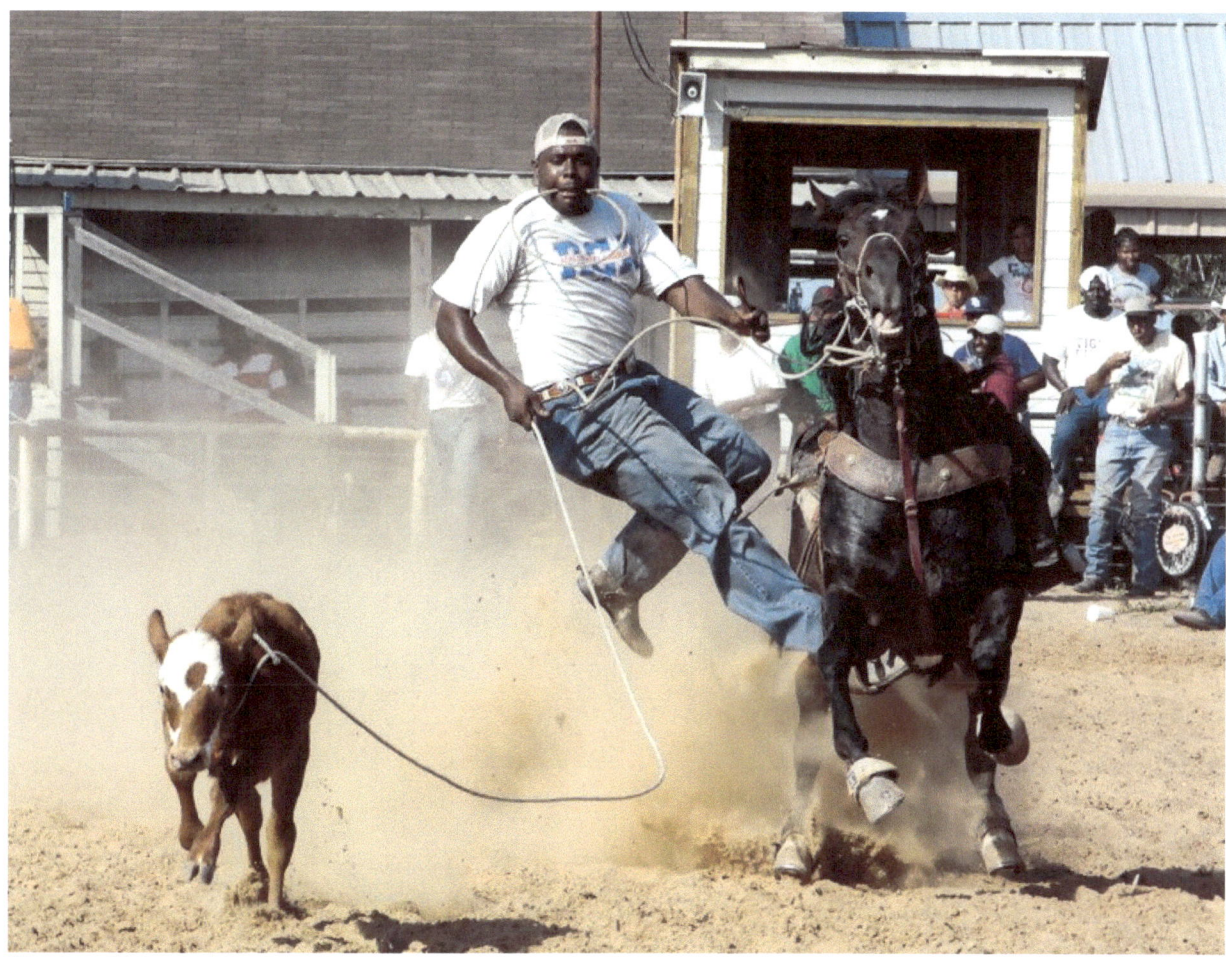

Cowboy Unknown
Carlyle King's Roping Arena

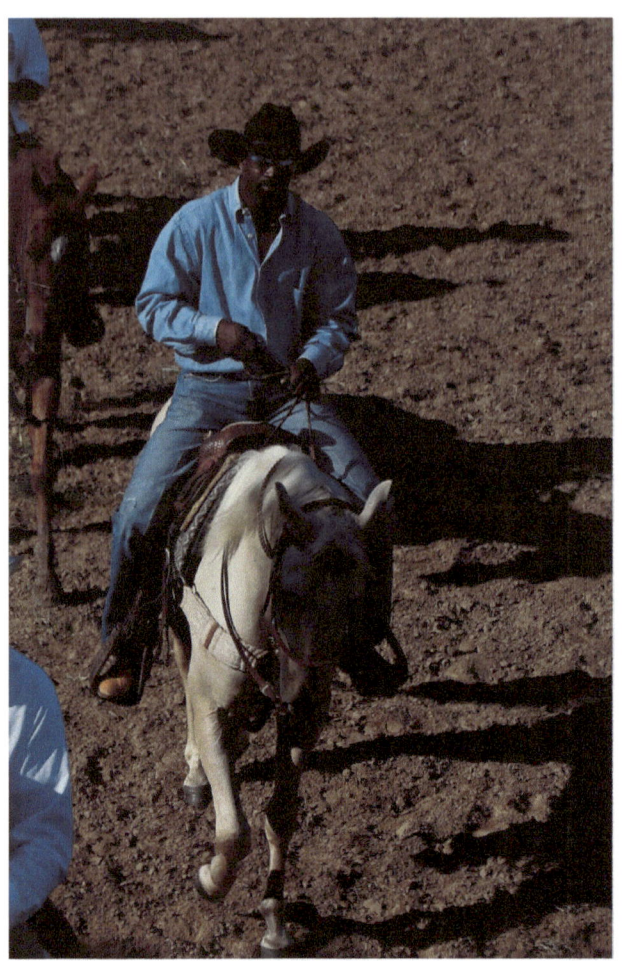

Cowboy
Calf Roper
Gene Roberts

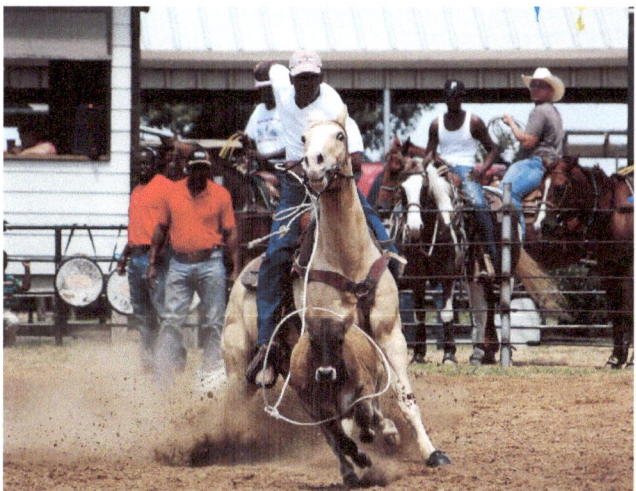

Cowboy Unknown
Break-away Roper

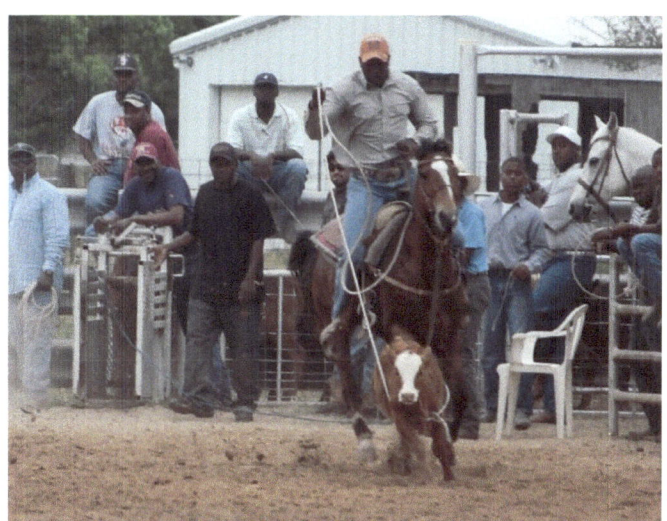

Cowboy Unknown
Break-away Roper

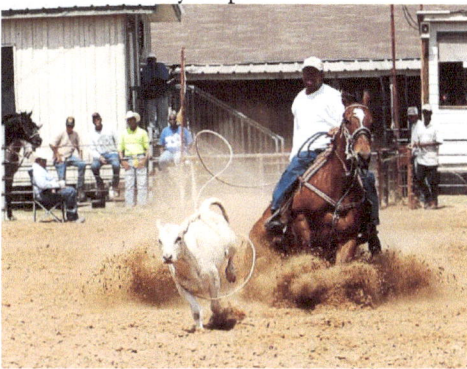

Cowboy Unknown
Break-away Roper

ized
Bareback Riding

Bareback riding is a rough and explosive event in rodeo. The most physically demanding of all the rodeo events in the Southeast Texas Rodeo circuits, it gradually became an event that has been eliminated. Cowboys ride rough horses without the benefit of saddle or rein.

They ride 'bareback' on the horse and use a leather rigging, which looks like a heavy piece of leather with a suitcase handle. The cowboys ride one handed and cannot touch themselves or the horse with their free hand. The cowboys spur the horse from shoulder to rigging, in a frantic style trying to make a qualified ride of 8 seconds. Once the ride is done, pick-up men swoop in to 'pick up' the rider and set him safely on the ground.

Cowboys are judged on their control and spurring technique, and the horses are judged on their power, speed, and agility. A good score in the bareback riding is in the mid 80's.

Cowboys competing in bareback take a lot of punishment on their arm, neck, and back due to the power and quickness of the horse.

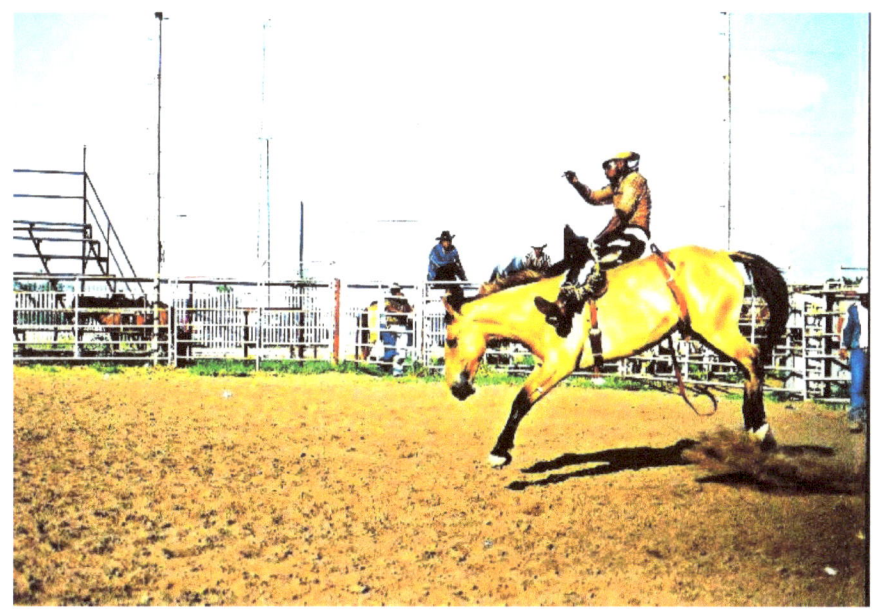

Cowboy, Unknown
Bareback Riding
Kendleton, Texas

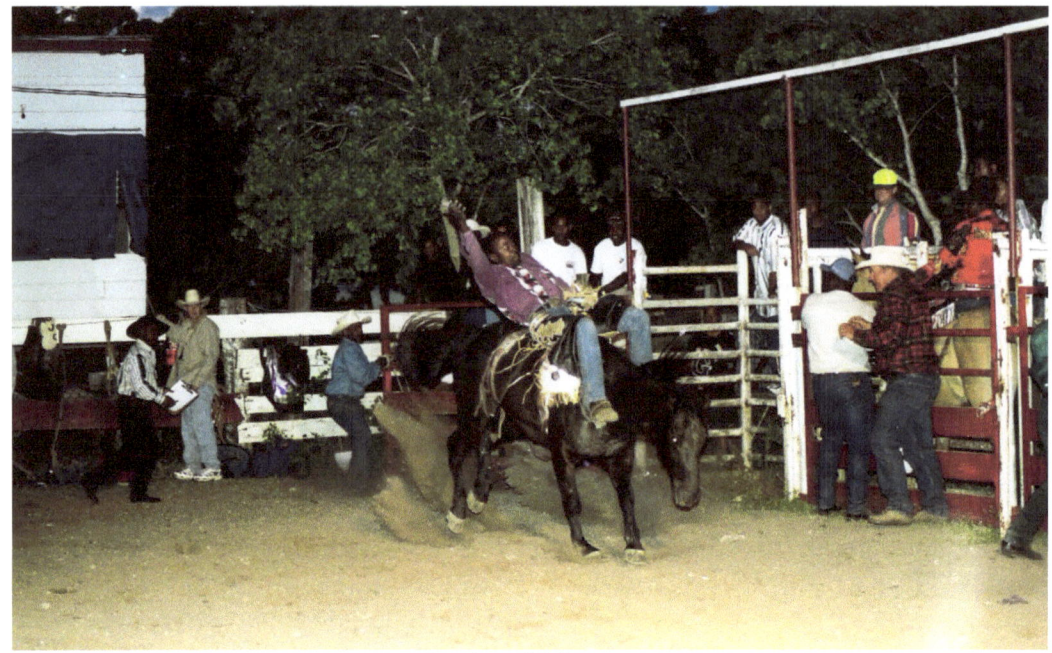

Cowboy, Unknown
Bareback Riding
Diamond L Ranch
Houston, Texas

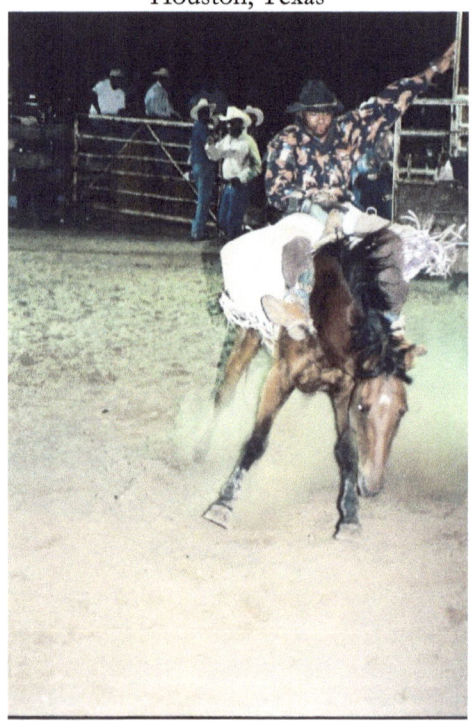

Cowboy, Unknown
Bareback Riding

Steer Wrestling/ Bull-Dogging

Steer wrestling, also known as bulldogging is the quickest of the rodeo events. It requires strength, speed, and timing. Many of steer wrestlers are large, hefty cowboys which is why this event is sometimes called the big man's event. Steer wrestling is a timed event, and cowboys compete against each other and the clock.

Bulldoggers **start** out in the **box** just like the **tie-down** roper. The **barrier** is placed across the box and the steer is loaded into the roping chute. As soon as the cowboy nods his head the steer is released and he charges after it on his horse. The steer wrestler catches up to the steer as quickly as possible and then leans over, jumps off of his horse and grabs the steer by its head. The bulldogger then plants his feet and tosses the steer onto its side, thereby stopping the clock.

Steer wrestlers require the use of a **hazer** to keep the steer running straight and from turning away from them.

A winning time is usually between 3 to 4 seconds, but these big boys keep getting faster and faster. Breaking the barrier in steer wrestling results in a 10 second penalty which puts you out of the **money**.

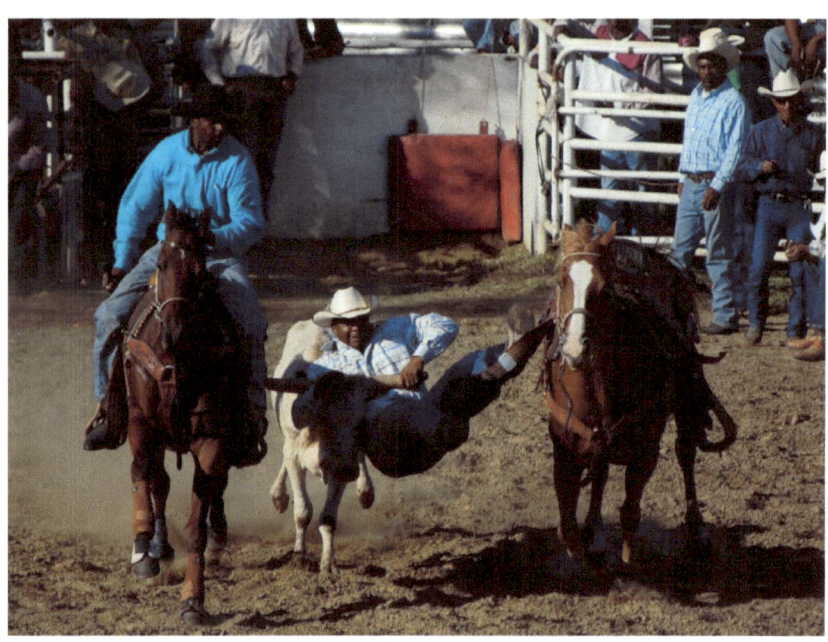

Cowboy, Unknown
Steer Wrestling
Rivon's Rodeo Arena
Raywood, Texas

Southeast Texas New Millennium Cowboy 1999-2010

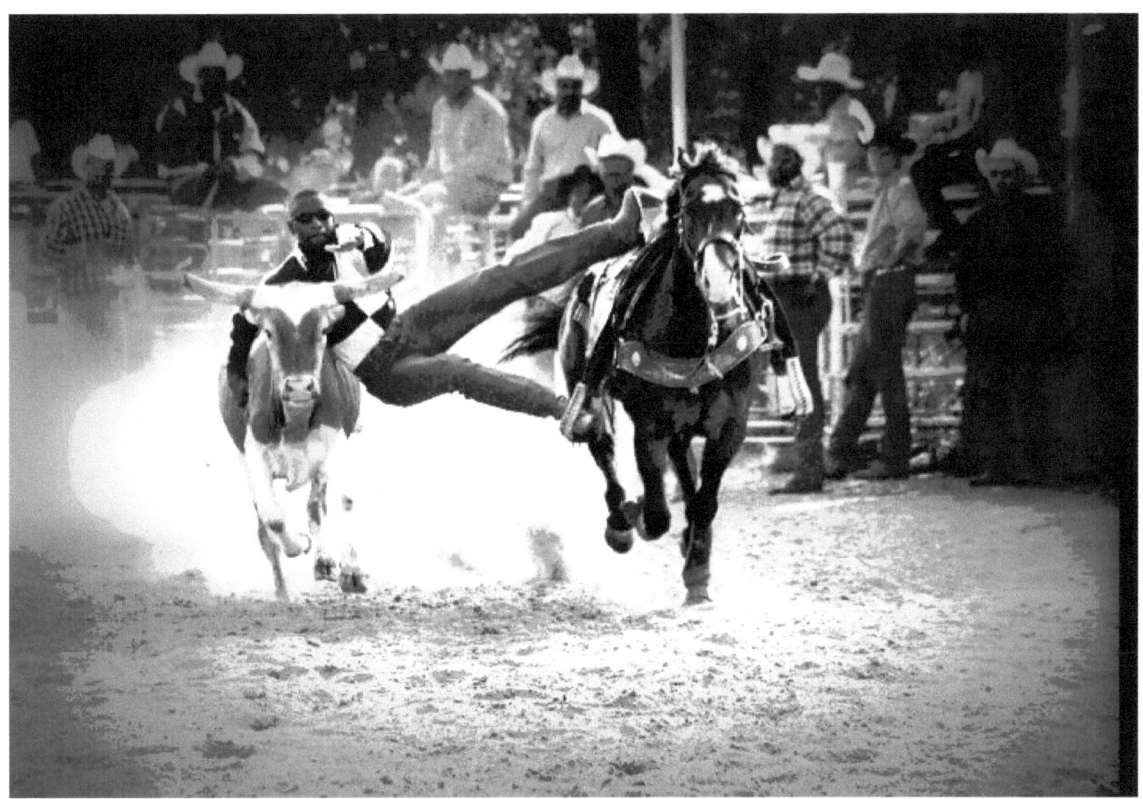

Cowboy, Unknown
Steer Wrestling
Circle 6 Rodeo Arena
Ames, Texas

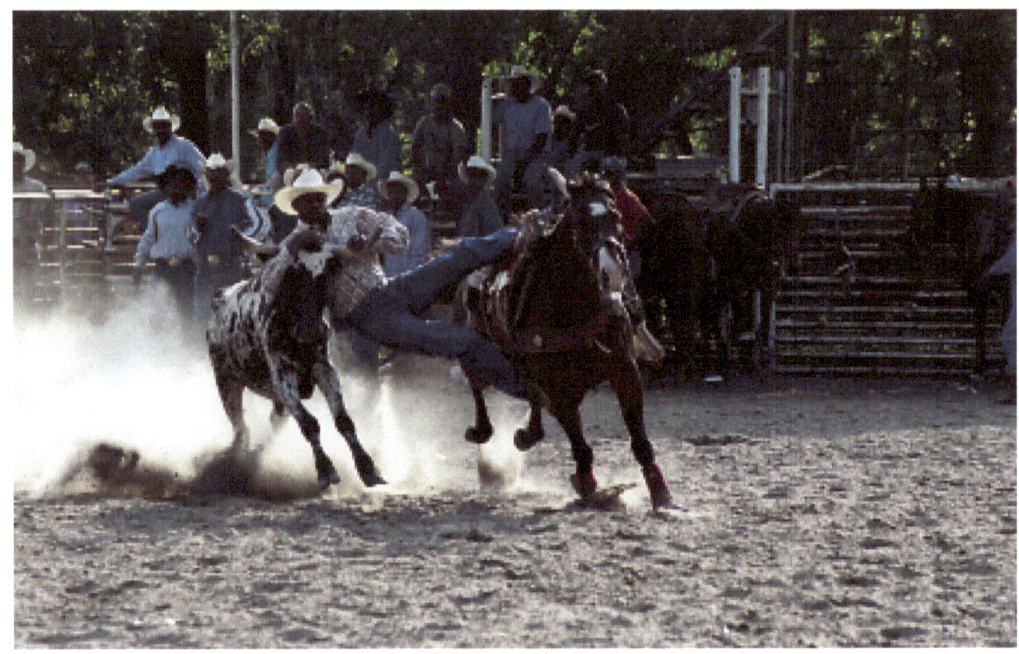
Cowboy Unknown
Steer Wrestler

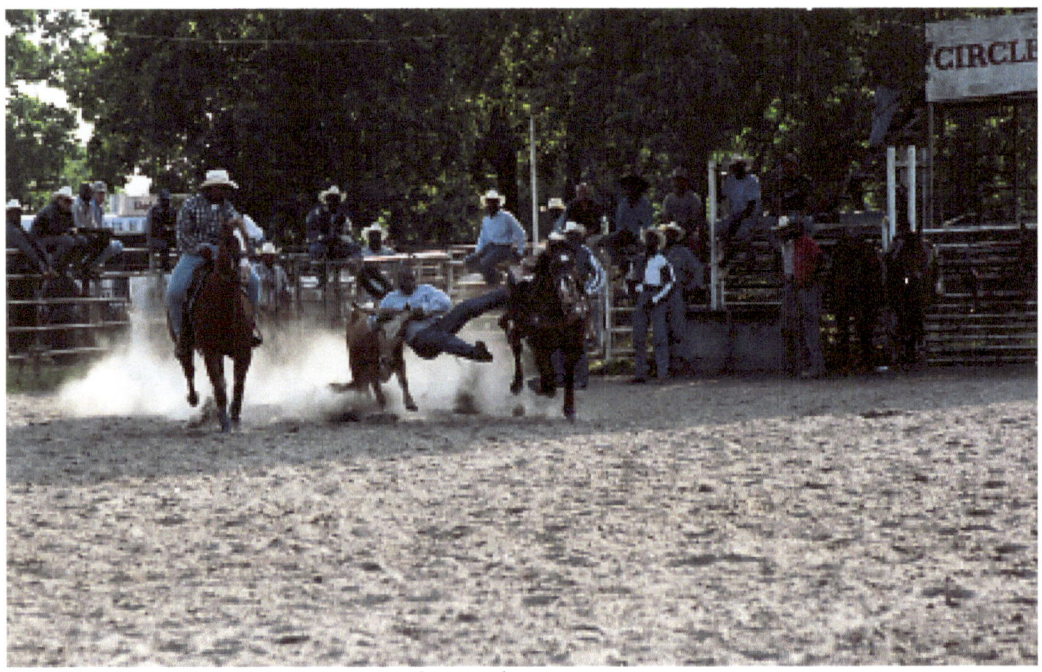
Cowboy Unknown
Steer Wrestler

Bull Riding

Bull riding is perhaps the most recognized and popular of all the rodeo events. It is also the most dangerous.

Bull riding is a sport in which a rider (often referred to as the cowboy) tries to **remain** mounted on a large bull as the bull tries to buck him off. Riders and bulls are usually matched up at random prior to the start of a competition.

Bull riders ride with one hand and cannot touch themselves or their bull with the free hand. Doing so results in a no score.

Judges award points based on how both riders and their animals perform as detailed below:

Scoring is the same as in the other rough stock events. Two judges give 1-25 points for the cowboy's performance and 1-25 points for the animal's performance. 100 points being the maximum, and is considered a perfect ride.

To ride, bull riders use a bull rope and rosin. The bull rope is a thickly braided rope with a cowbell attached. The cowbell acts as a weight, allowing the rope to safely fall off the bull when the ride is over. The rosin is a sticky substance that increases the grip on their ropes. Bull riders wrap their bull rope around the bull and use the remainder to wrap around their hand tightly, trying to secure themselves to the bull.

Unlike the horse events, there is no mark out in bull riding. Cowboys can spur for extra points, but just staying on the bull for 8 seconds is the main priority. After the ride, bull riders are aided by bullfighters or rodeo clowns and barrel men who distract the bull, allowing the cowboys to escape safely. A good score in the bull riding is in the 90's.

Bull riding requires balance, flexibility, coordination, and courage. Facing down a two-thousand pound bull takes as much mental preparation as it does physical ability.

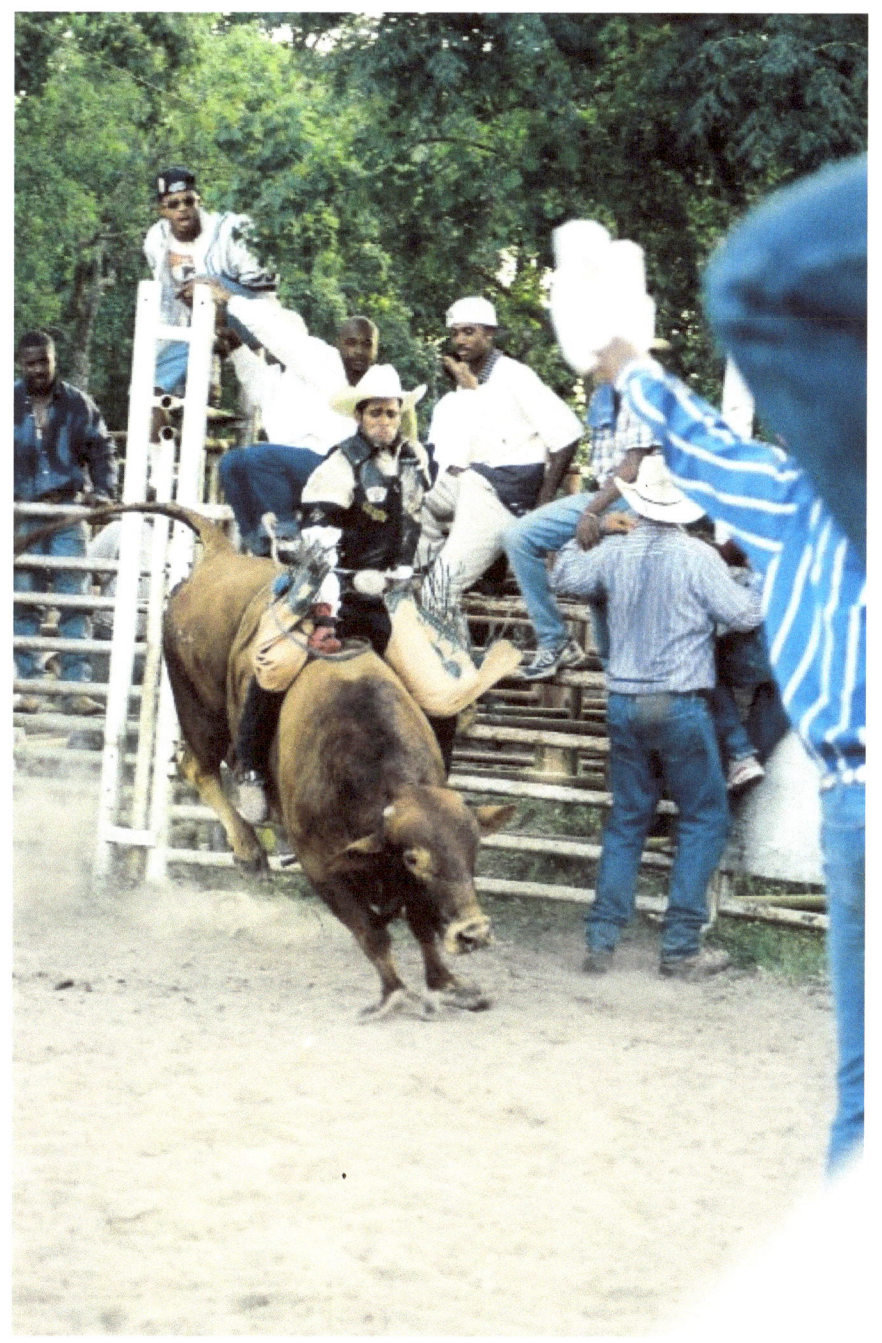

Cowboy, Unknown
Bull Riding
Circle 6 Rodeo Arena
Ames, Texas

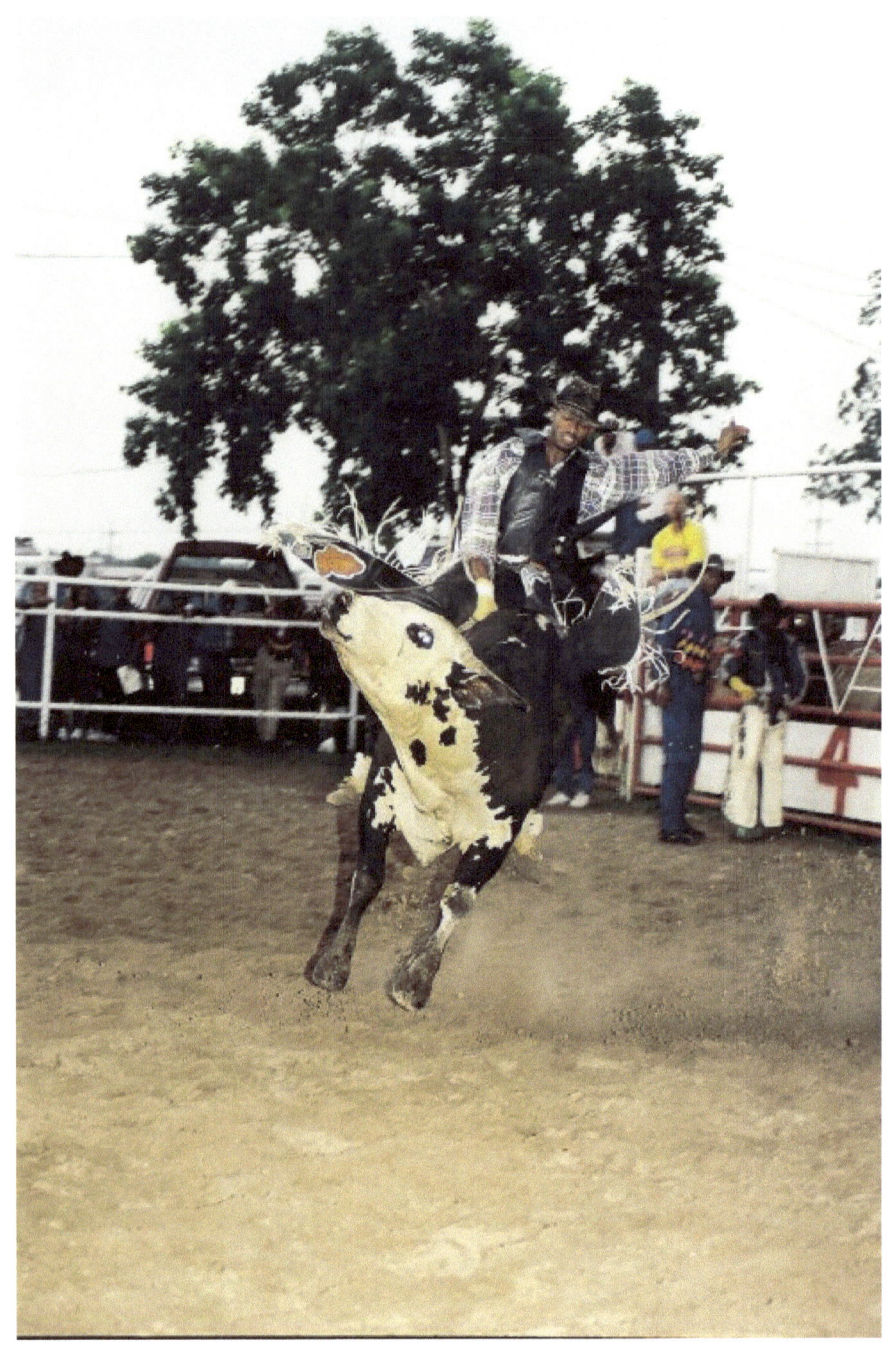

Cowboy, Unknown
Bull Riding
Rivon's Rodeo Arena
Raywood, Texas

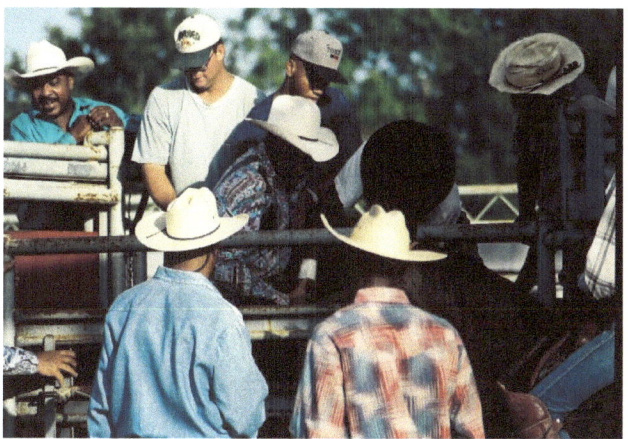

Bull riders preparing for the ride.

Cowboys Unknown

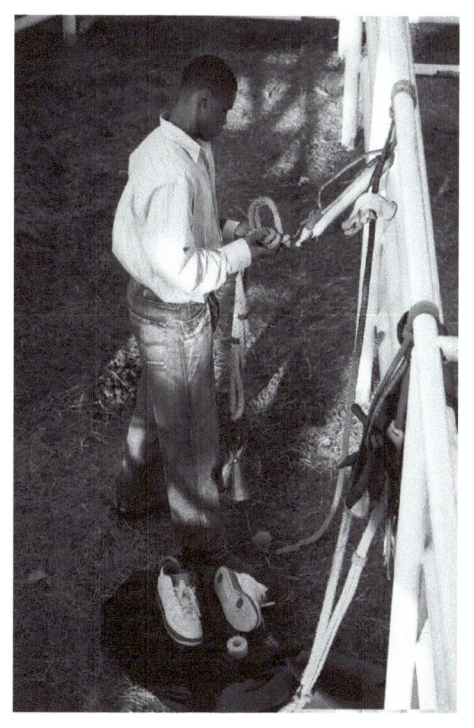

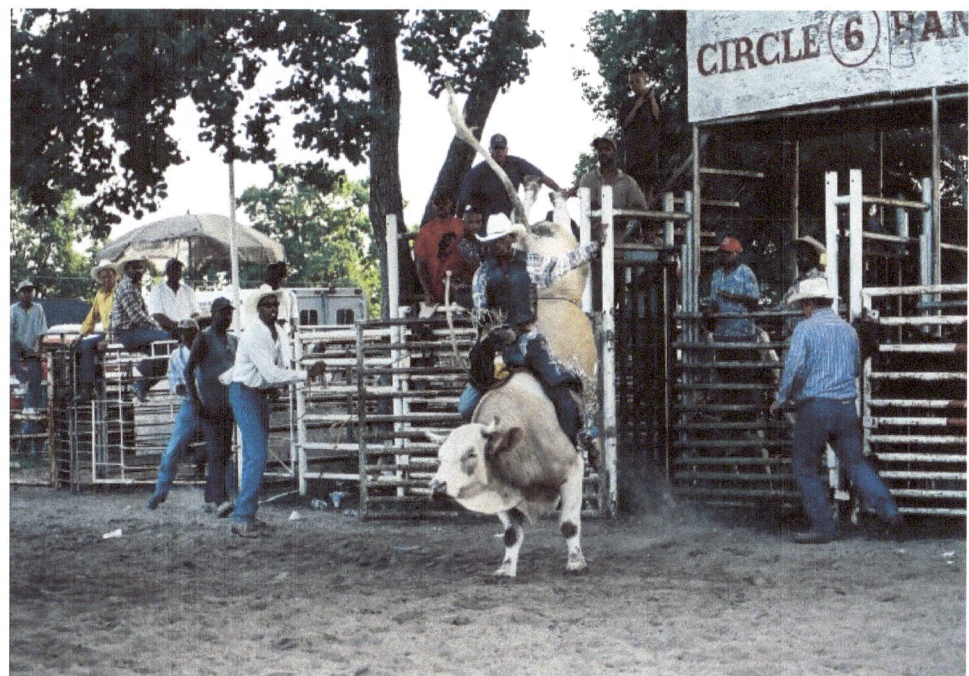

Cowboy, Unknown
Circle 6 Ranch
Ames, Texas

Barrel Racing

Barrel racing is a timed rodeo event, where the fastest time is what matters most. Cowgirls compete in the arena against each other and the clock.

Barrel racing is about cooperation between horse and rider. Because of the competition and **money** involved, finding a good horse is very important to the competitors.

For the barrel racing event, the arena is cleared and three barrels are set up at different marked locations. The riders then enter the arena at full speed, quickly rounding each barrel in a cloverleaf pattern and then exiting where they entered. A stopwatch or timer is used registering down to a hundredth of a second.

Speed is what it is all about in this event. The riders steer their horses as **close** as they can to the barrels trying to shave precious seconds off the clock. For each barrel they knock over (which happens sometimes) a 5 second penalty is assessed to their total time. Leaving the barrels standing and ripping through the course is every barrel racers goal.

13 to 14 seconds is generally a winning time in this event, but this will vary according to the size of the arena.

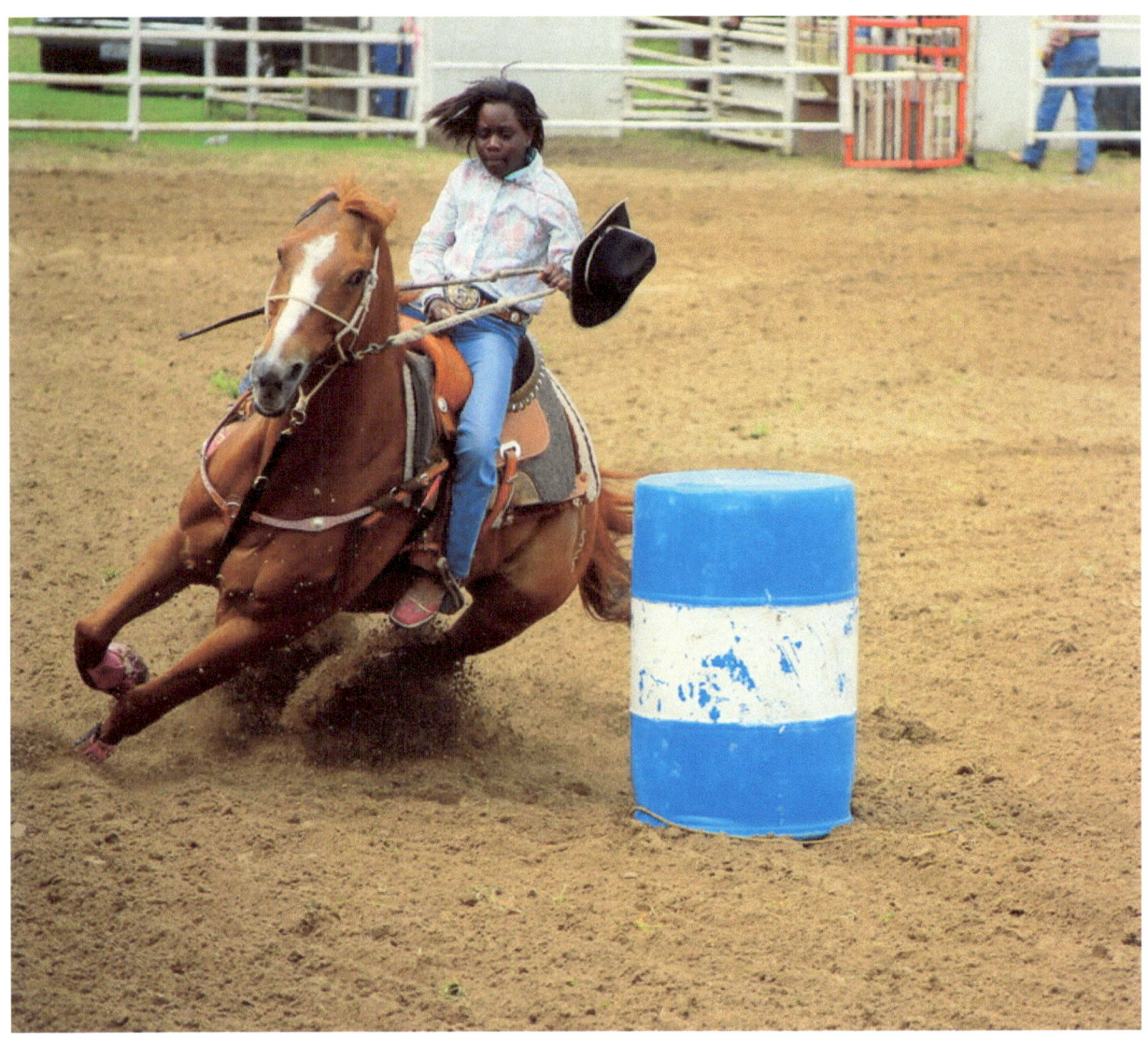

Cowgirl Unknown
Barrel Racer

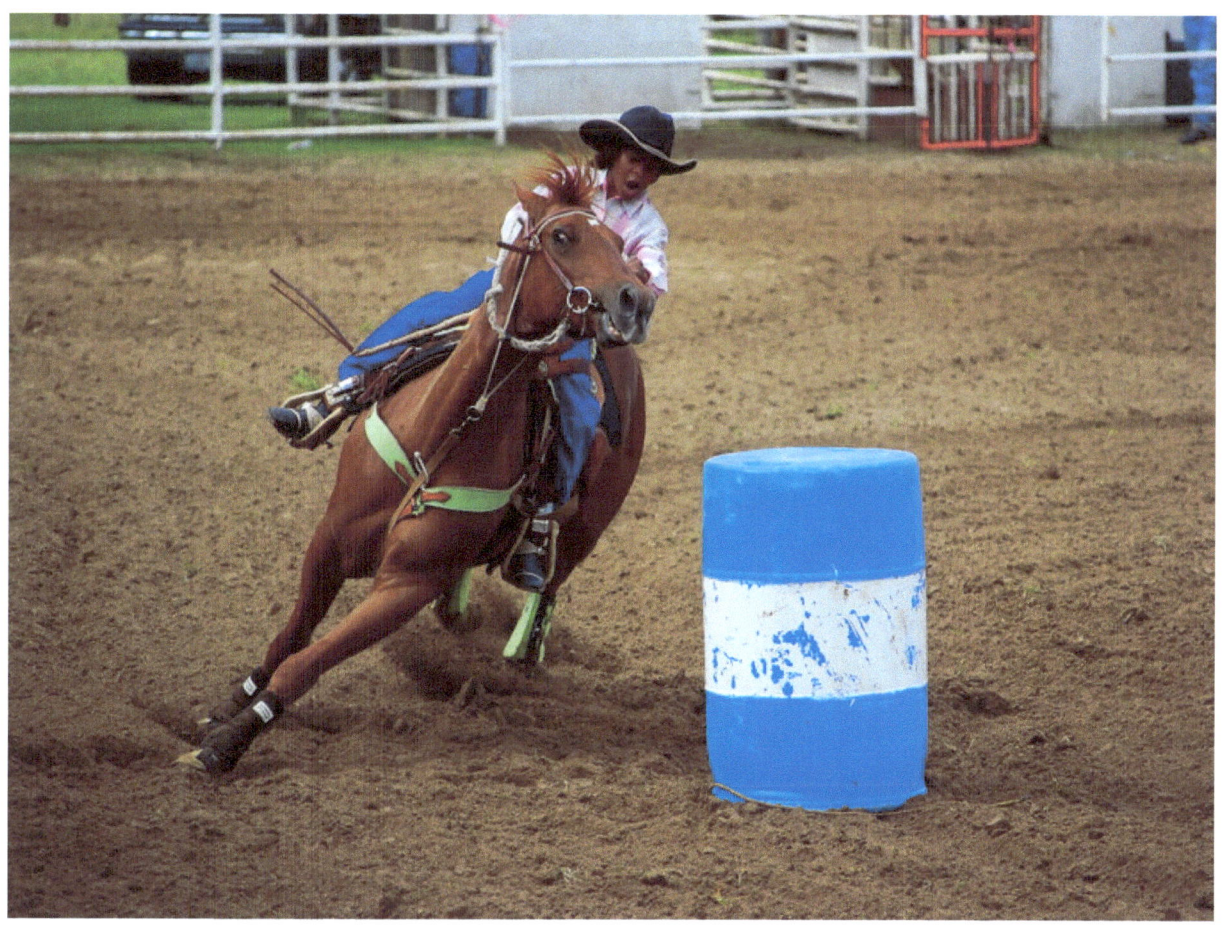

Cowgirl Unknown
Barrel Racer

www.ingramcontent.com/pod-product-compliance
Lightning Source LLC
Chambersburg PA
CBHW050416180526
45159CB00005B/2299